Rodney Carswell, Selected Works: 1975–1993

The Renaissance Society at The University of Chicago

March 7–April 18, 1993

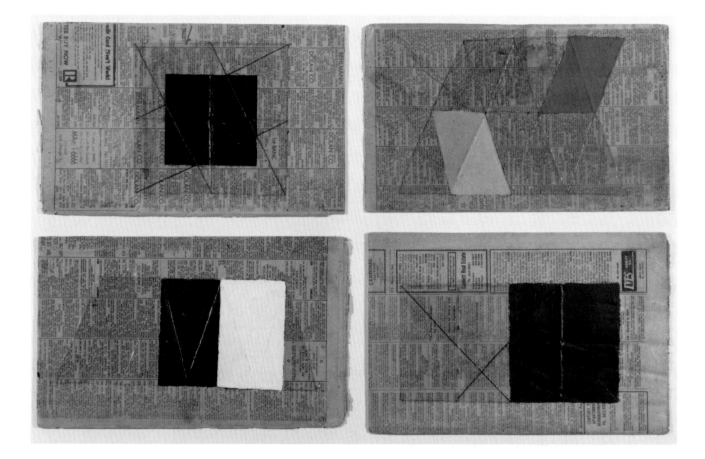

Newspaper Group, numbers 6, 7, 13, 17, 1975

Acrylic on newspaper, 20½ x 29½ inches

Acknowledgements

The Renaissance Society and its membership are pleased and grateful for the opportunity to present the exhibition *Rodney Carswell, Selected Works: 1975–1993,* which continues The Society's important series of retrospectives honoring the work of outstanding Chicago artists. We extend our thanks to Rodney for accepting the invitation to work with us and particularly for so generously sharing his resources, information, and confidence, which we have enjoyed throughout the preceding year.

We are especially grateful to art historian and *Los Angeles Times* critic David Pagel, for providing a critical essay; to Michael Glass and Michael Glass Design of Chicago, for the excellence and generosity in their design work on the catalogue and invitation; to Paul Baker Typography, Inc. of Evanston, for their careful work with the typesetting; and to Meridian Printing of Rhode Island, for their production expertise.

Special thanks are extended to the staff of The Renaissance Society: Randolph Alexander, Development Director; Joseph Scanlan, Assistant Director; Karen Reimer, Preparator; Patricia A. Scott, Bookkeeper and Secretary; and Steven Drake, Kristine Veenstra, and Farida Doctor, gallery assistants. Their personal interest and diligent work greatly strengthened the organization of the exhibition and this publication.

As always, my deep appreciation and gratitude for their continuing support and trust go to the Board of Directors of The Renaissance Society. I hope the reader will take the time to look through the list of these outstanding individuals from the Chicago community who contribute so generously of their time, energy, and resources.

In particular we would like to thank Sahara Coal Company, Inc., LaSalle National Bank, Chicago, and the Elizabeth Firestone Graham Foundation, whose generous support has made this publication possible.

Rodney Carswell, Selected Works: 1975–1993 is sponsored in part by the Illinois Arts Council, a state agency; by the CityArts Program of the Chicago Department of Cultural Affairs, a municipal agency; and by our membership. Indirect support has been received from the Institute of Museum Services, a federal agency offering general operating support to the nation's museums.

Generous support for the exhibition and catalogue has been received from The School of Art and Design and The College of Architecture, Art, and Urban Planning at The University of Illinois at Chicago, and from Linda Durham, Timothy and Suzette Flood, Martin Friedman, Daryl E. Gerber, Michael Glass and Michael Glass Design, Jack and Sandra Guthman, Thomas C. and Linda Heagy, Jessica D. Holt, and Claire F. and Gordon Prussian.

Susanne Ghez
Director

Rodney Carswell: Exacting the Balance

At once measured and ungrounded, exceedingly deliberate and decidedly arbitrary, Rodney Carswell's three-dimensional paintings from the past five years fuse restraint and unpredictability in constructions whose tight organizations defy logic yet make sense. His labor-intensive structures, solidly built with high-quality (but never extravagant) lumber, testify to the presence of an ethos in which hard work, foresight, and practicality are highly valued. Carswell's patiently built-up and scraped-down surfaces of oil paint mixed with wax manifest a strong sense of dedicated self-effacement, an almost ritualistic immersion in the impersonal rhythms of work. Here, signs of struggle and evidence of an individual's uniqueness are less important than a job well done. In conjunction with wide expanses of dry, slightly modulated colors, a palette of consistently muted tones, and simple compositions that tend toward the iconic and the architectural, his paintings stamp themselves out in space as oddly ordered configurations that are both randomly off-balanced and rigorously geometric, blandly generic and distinct.

They function less as purely abstract images than as contingent objects that are nothing if not straightforward. With a sort of Minimalist severity softened by a hands-on, "just-the-facts-please" earnestness, Carswell's subdued pieces are accompanied by no-nonsense titles that inventory the physical properties of their components without giving away any of the mysteriousness they seem to hold in reserve. Their uneven but repeated arrangements on and out from the wall compound the sense that they almost fit into a serial structure of systematic, quasi-alphabetic meaning, but never completely follow the logic of any decipherable code. Paradoxically, Carswell's works prove themselves to be profoundly resistant to rational explanation. In his direct yet withdrawn art, surface, support, and depiction converge into singular entities that cannot properly be described as unified wholes. His recent paintings are at once generous and guarded. They seem, simultaneously, to immediately express everything on their plainly visible surfaces and yet to withhold their significance from such swift perusal. They substantiate, even if they refuse to articulate, a strange, understated sense of being exactly, if moderately, out of whack.

Despite—or precisely because of—the precision and consistency with which they are made, Carswell's masterfully crafted and intensely controlled constructions show themselves to be at cross purposes. His blunt, sometimes uncanny paintings are both utterly ordinary and undeniably weird, not quite to the point of being willfully perverse, but, in their own quietly original and eccentric manner, well out of step with convention and expectation. Hardly ever contradictory, never divisive, and rarely more than optically animated, his intelligently studied explorations of simple, formalist issues are riddled—sometimes literally—with elements that do not add up, align with one another, or cohere in harmonious compositions. Without being visually dissonant, conceptually disruptive, or flamboyantly self-involved, Carswell's hybrid constructions take their place in a strangely familiar realm, one that collapses clarity and directness together with an almost naive sense of not really knowing what's going on.

Although the images and structures of his paintings recall those of Russian Constructivism and Suprematism, and seem haunted by the memory of Renaissance altar-pieces and the freestanding retablos from churches in the American Southwest, his carefully fabricated abstractions never have the presence of glib quotations or parasitic appropriations. It is as if Carswell's objects have not only refused to believe in the theories that dominate contemporary art criticism, they have also stubbornly resisted the art history lessons that they were supposed to have absorbed. His work is driven by the insistence that second-hand knowledge is useful only as a hint or a suggestion about the direction in which one might best proceed. His solidly built structures are based on the belief that if anything is significant it must be discovered for oneself, in the painstaking and patient scrutiny of the nuances of one's own fleeting perceptual experiences. A strange conflation of deep suspi-

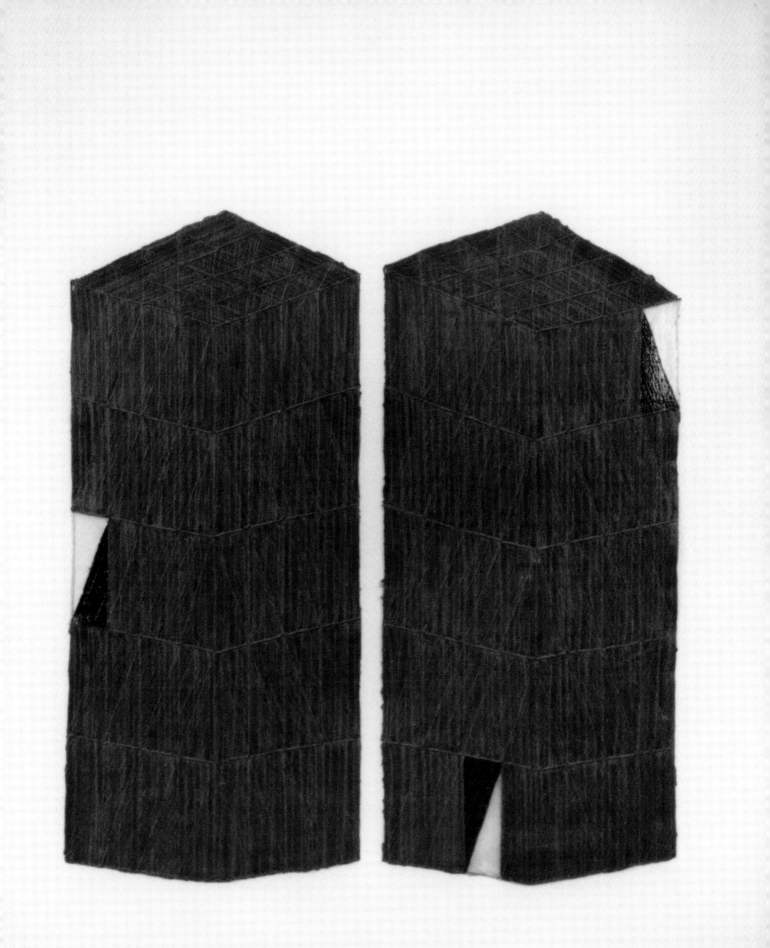

Twin Towers, 1976

Acrylic on canvas, 50 x 44 inches

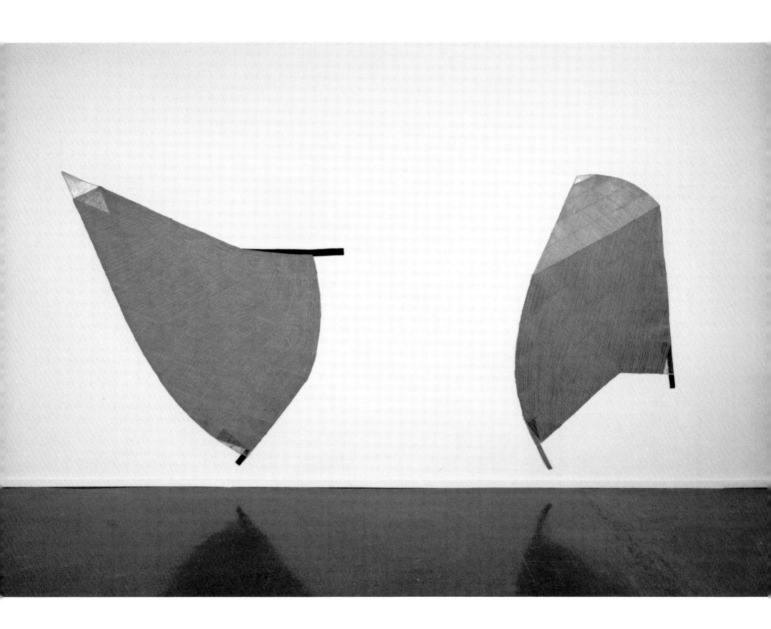

Martha, 1977

Acrylic on canvas, 67 x 68 inches

Twyla, 1978

Acrylic on canvas, 68 x 37½ inches

cion and profound trust thus governs Carswell's art. His paintings give substantial physical form to the disjuncture between what one knows and what one does, between adamantly professed beliefs and verifiable actions. They negotiate a difficult if seemingly simple balance between accepting fate's utterly arbitrary nature and tirelessly acting as if controlling its unfathomable movements is not only possible, but virtuous.

An irregular intersection or an uneven, repeated overlap of crosses, circles, squares, and rectangles defines the shifting parameters of Carswell's highly focused explorations of form. Rather than tracking a consistent and continual movement from lesser to greater complexity, or following neat, linear progression through the resolution of increasingly refined abstract problems, his body of work from the past five years establishes a pattern of doubling back upon itself, of returning to earlier concerns and compositions to determine whether they unfolded as they did out of something like necessity or merely by the random operations of chance. Doubt, and its tenuous but essential undoing, animates Carswell's quietly ambitious project.

Proceeding sporadically, by means of continuous starts and stops, of cautious movements in one direction and stuttering steps in another, the works he made between 1988 and 1992 constitute an ongoing, tenacious interrogation of the interplay between accidents and intentions, willful deliberation and unpredictable serendipity. An accurate (if schematic) map of Carswell's emblematic abstractions necessarily resembles a structure of branching paths that simultaneously spread out in space and circle back onto one another, forming an elaborate criss-crossing network of interconnected segments. His iterated inquiry into the forces or tensions that hold lines and planes together—and repel them from one another—does not congeal or cohere in a hermetic, one-dimensional system, but opens onto the possibility of its incessant rearrangement, of falling into a significantly different pattern each time it is again reconfigured as an ostensibly finished whole. Each of Carswell's objects instantiates a microcosmic version of the (il)logic at the root of his *oeuvre*. At once incomplete and autonomous, his individual paintings function as components of a system that is itself based on contingency and inconsistency, on repeated rhythms and their sometimes sudden, if ongoing interruptions. Arranged in different, temporary groupings, or ad hoc constellations, they invite us to reshuffle their elements according to incompatible categories and incongruous typologies, to conventional concepts that themselves seem to be based on little more than randomness and whim.

The gap between shape and support—or the disjuncture between two-dimensional image and three-dimensional form—provides the abstract, conceptual ground for Carswell's materially oriented works from the past five years. In paintings such as "Tri-Color Cross Encircled in 3 Gray Panels" (1988), "Cross: Split, Tilted, Squared" (1989), "Cross in Light Gray-Green (Split) with 3 Holes" (1991), and "Blue Circle Encircled (Crossed)" (1992), this ambiguous, unrepresentable territory is traversed as if its boundaries were those of a game and its logical operations belonged to a puzzle. These four seemingly straightforward constructions play out some of the permutations of a potentially infinite arrangement of simple geometric elements, as if Carswell were putting together a series of oversized homemade jigsaw puzzles whose pieces fit snugly into one another's contours but never added up to complete, definable wholes. These exemplary works have the contradictory presence of improvised adaptations to problems discovered in the process of their construction, and finished products whose final compositions have been perfectly and completely planned in advance. They seem, at once, to have been assembled from prefabricated kits and to have grown, more organically, out of an inventive handyman's solutions to practical design problems, in which ordinary materials and readily available resources have been adapted to unforeseen purposes and used to reach unanticipated (but no less necessary) ends. Carswell's flat-footed titles, in which nouns and verbs shift positions or exist as both forms simultaneously, begin to describe this sense of multipurposeness or quality of dual functionality. The way he puts words together matches or mirrors the way he puts shapes and forms together: the verbal and visual elements of his paintings describe both actions and objects, the concrete manifestations of conscious decisions and directed efforts, as well as the mute physical presence of inert materials and inanimate matter.

In "Tri-Color Cross Encircled in 3 Gray Panels" a cross, a circle, and a square inhabit the same pictorial plane, but seem less locked in fixed positions there than temporarily held in place by an unsteady balance of opposing forces. Each of the painting's three geometric components is made up of three separate but similar elements. The cross (which also might be a plus sign) consists of a red, a white, and two black bars; the circle is made up of a thin line inscribed as three unequal arcs; and the more than seven-foot blue-gray square that defines the perimeter of the painting has been built out of a smaller square and two abutted rectangles of similar width but different lengths. The overall image is held together as a whole by Carswell's fusion of its objective and illusionistic components. By using the edges of the three blue-gray fields as lines "drawn" in space, he allows us to make sense of his image's unbalanced, off-kilter composition. The cross, which sits heavily, low and to the left of the circle's center, fits perfectly into the center of the square field, exactly bisecting it into four equal quadrants. Sorting out the arrangement of the elements in Carswell's painting consists in discovering the structural necessity of its constitutive parts—the parallel relationships between the odd cross in the small square and the drawn circle in the larger, overlapping one. "Tri-Color Cross Encircled in 3 Gray Panels" has the temporality of a part-by-part construction, of an ongoing process in which the artist added individual elements to one another until some sort of balanced resolution was achieved. Its casual, ad hoc, improvisational quality results from Carswell's refusal to start over from scratch, to undo what he has already done, as if to fix every element in an absolutely consistent composition. His piece insists that the tension between idealized geometry and its contingent, practical realization is what gives art its vital energy.

This phenomenon of additive adjustment is condensed into a more compressed temporal span of almost simultaneous experience in "Cross: Split, Tilted, Squared." Focusing on a single point in space and time, Carswell's human-scaled painting literally breaks into two separate planes—actually tips steeply to one side—and visually divides into four, chromatically distinct areas. Nevertheless, it still maintains its presence as a crisp, singular image, as a unified component of objective reality that decisively stamps itself out as a whole. Rather than manifesting a sense of ongoing adaptation—of tentatively truing and faring, calibrating and reconsidering—Carswell's bold form fuses these openly experimental explorations into a tight, neatly circumscribed formal arrangement that is animated by its potential for disequilibrium, or charged by the possibility of its impending breakdown: first into fragments, then into incoherence.

Like a list of things you can do to a cross without destroying its essential identity, "Cross: Split, Tilted, Squared" juggles a number of opposing forces. By holding a sense of accumulative construction against one of potential disintegration—or by locating static fixation and spinning mobility in the same space—his off-balance painting plays out of the gap between materiality and abstraction. Carswell's compressed collision of lines, planes, and edges takes its place at the intersection of ideas and objects, where concepts cross paths with materials, sometimes holding them together in consistent constellations and at others refusing to accept the provisional coherence their imperfect orderings imply. His painting neither defers to the power of rationality and logic nor insists on the priority of inarticulate materiality, but treats each as indispensable, reciprocal components of an unarrestible balancing act.

Likewise, the evident symmetry between the left and right panels of "Cross in Light Gray-Green (Split) with 3 Holes" is immediately disrupted by the three round holes that randomly punctuate the meticulously painted surfaces of Carswell's rectangular construction. Once again, pictorial elements are constructed both illusionistically and literally, and the presence of animated movement is hinted at but held in check by the physical solidity of the painting, by the sense of uneventful stability with which it hangs on the wall. A six-foot-tall cross stands at the base of Carswell's abstract diptych and reaches all the way across the width of the vertically abutted panels. This cruciform shape floats into visual focus like a shadow or after-image just after your eyes and brain have registered the presence of the playful, seemingly irresponsible holes. With an extreme economy of means, the evanescent, halo-like cross endows the painting with the contradictory aura of subdued serenity and dramatic violence. It haunts the composition with a sense of

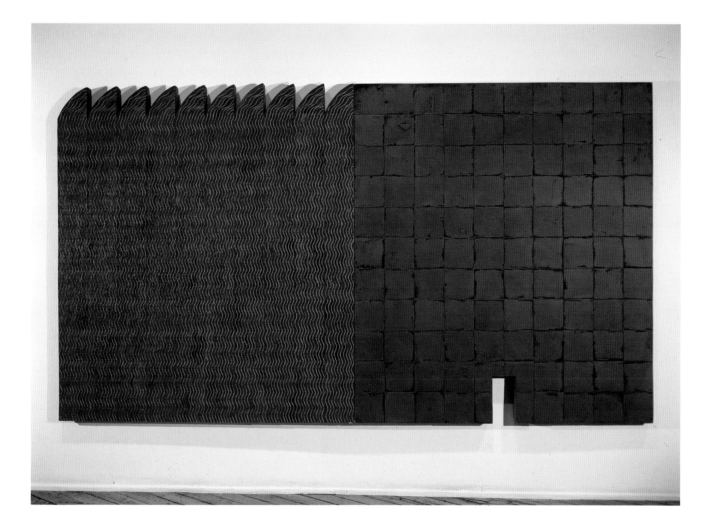

Fire in the City, 1980

Acrylic and compound on board, 55 x 100 inches

melancholia and an impulse toward memorialization at the same time that the holes both exaggerate and overturn the sentiments of loss embodied by the cross. Where the holes act as absolute gaps, complete deletions, and utter obliterations of whatever used to occupy their spaces, the iconic cross functions to draw out in time the fact of disappearance—to indulge memory's need to savor the echoes and resonances of a vanishing past that only increases its existential force as it fades away in the present. Carswell's understated, almost monochromatic painting downplays jarring visual incidents to more profoundly play out the emotional reverberations of these abstract structures and fleeting temporal movements.

Like "Cross in Light Gray-Green (Split) with 3 Holes," "Blue Circle Encircled (Crossed)" neither records the additive process by which it was made nor establishes a unified design that immediately asserts its overall gestalt, but defines a strangely consolidated version of these two movements at once. Related yet distinct, overlapping yet incommensurate, these dual movements share the same pictorial space by preventing it from wholly settling into either conventional form of resolution. This roundabout painting consists of a ten-inch band of stretched canvas that forms a circle with a diameter of approximately six feet. An off-center gray stripe runs all the way around this blue band, creating a warped orbit in vision that seems to pull the whole painting upward and to the left. A pair of thin, unpainted stretcher bars constitute a rudimentary cross that tips to the right, counteracting the illusionistic spin of the painted orb. By dividing a thin band of canvas into three uneven rings, and setting them in motion against the suggested roll of the spoke-like stretcher bars, Carswell's wheel of a painting continues his inquiry into the similarities and differences between literal forms and depicted shapes, elusive movement and concrete stasis, as well as contingent parts and autonomous wholes. Like all of his works from the past five years, "Blue Circle Encircled (Crossed)" revolves around a strictly delimited set of formal issues with such a surplus of quirky intensity that its tightly circumscribed geometric vocabulary draws into its boundaries an open-ended array of significant possibilities. Always about themselves but never only that, Carswell's quiet arrangements of surfaces, supports, and images circle back upon themselves, inviting their viewers into dialogues that have the potential to go in more than one direction at once, without ever leaving behind the straightforward materials with which they began.

A series of small acrylic paintings made on the pages of folded newspapers in 1975 inaugurates Carswell's tendency to move forward by doubling back. Each of these wonderfully mundane pieces consists of a compressed network of overlapping rectangles, squares, parallelograms, diamonds, and triangles laid out on the face of a thin section of newspaper that itself has been repeatedly folded in half until it is the size that fits comfortably under your arm. Carswell has painted some of these geometric shapes in the primary colors, black, white, or gray, and filled others in with transparent gel medium. Each arrangement of lines and shapes gives the impression that it, like a newspaper, could be folded up, transported, and spread out again for continued perusal. When these little images are juxtaposed to three of Carswell's most recent, large-scale pieces, the parallels and overlaps chart a remarkable consistency of purpose and an unwavering persistence of attention. "3 (5) Panels, Presented and Reversed" (1993), "Irregular Stack and Cross" (1993), and "Foursquare: Sectioned, Flipped, Obscured" (1992) function like elaborate, complex renditions of the basic formal principles at work in his early newspaper series. The first invites you to imaginatively unfold its three reversed canvases to form a fully exposed, ten-foot-long abstract screen. The second seems to have been built by a single red cross's ghostly migration—or mad, end-over-end flipping—around an odd-shaped plane, itself made up of an obsessively stacked arrangement of small rectangles. And the third, a silhouette of a cross, would unfold into a perfect square if its four subsidiary (and backward) canvases were attached by hinges and could swing back to reveal their faces, filling in the missing corners of the reversible form that alternates between being an odd cross and a plain square. Like Carswell's earliest studies on newspaper, each of these quasi-architectural constructions functions by folding back on itself, not in a defensive or hermetic gesture, but to double its signifying potential by more actively engaging the attention of its viewers.

Part of the power of Carswell's constructions is that no matter where in their sequence a viewer begins, each grouping manages to take you, with a sense of inevitability, through a determinate series of permutations. This movement is curious, even peculiar, because it never feels heavy-handed or manipulative, yet nevertheless delivers you to a specific position, one that has the presence of being accurately anticipated and thoroughly preplanned, if not compulsively or totally controlled. Moving through an installation of Carswell's paintings seems to leave you right where you started, except for the fact that a lurking suspicion prevents you from believing that you still see things the same way you did at the beginning. If Carswell's understated paintings refuse to grab your attention with flashy theatrics, they do not refrain from working their way into your consciousness in a more supple, somewhat unsettling manner. By managing to look slightly different each time they are seen, his works require you to undertake an analysis that pits memory against experience, plays intimacy against distance, and holds the reciprocity of two-way exchanges in tension with the authority of unilateral movements. Echoing out of the intrinsic incommensurability between perception and cognition, his abstract objects elicit a type of potentially continuous, ongoing attention, one that shares more with peripheral vision than direct, head-on scrutiny. Gradually, by means of incremental alterations and minor shifts in sight, what seem to be unremarkable insights accumulate around the surfaces of Carswell's multiple panels in configurations that are undeniably slight, often extremely subtle, but always just enough to make a difference.

David Pagel
February, 1993

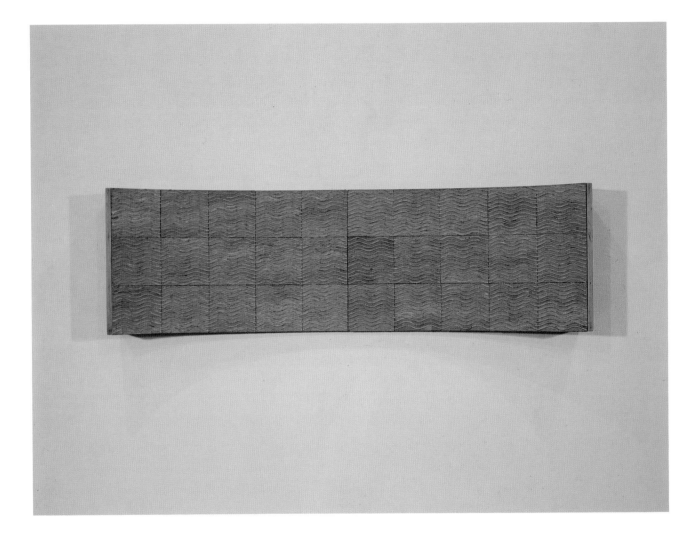

St. Tropez, 1978

Acrylic on board, 15 x 50 x 3½ inches

St. Tropez, 1978 (side view)

Acrylic on board, 15 x 3½ inches

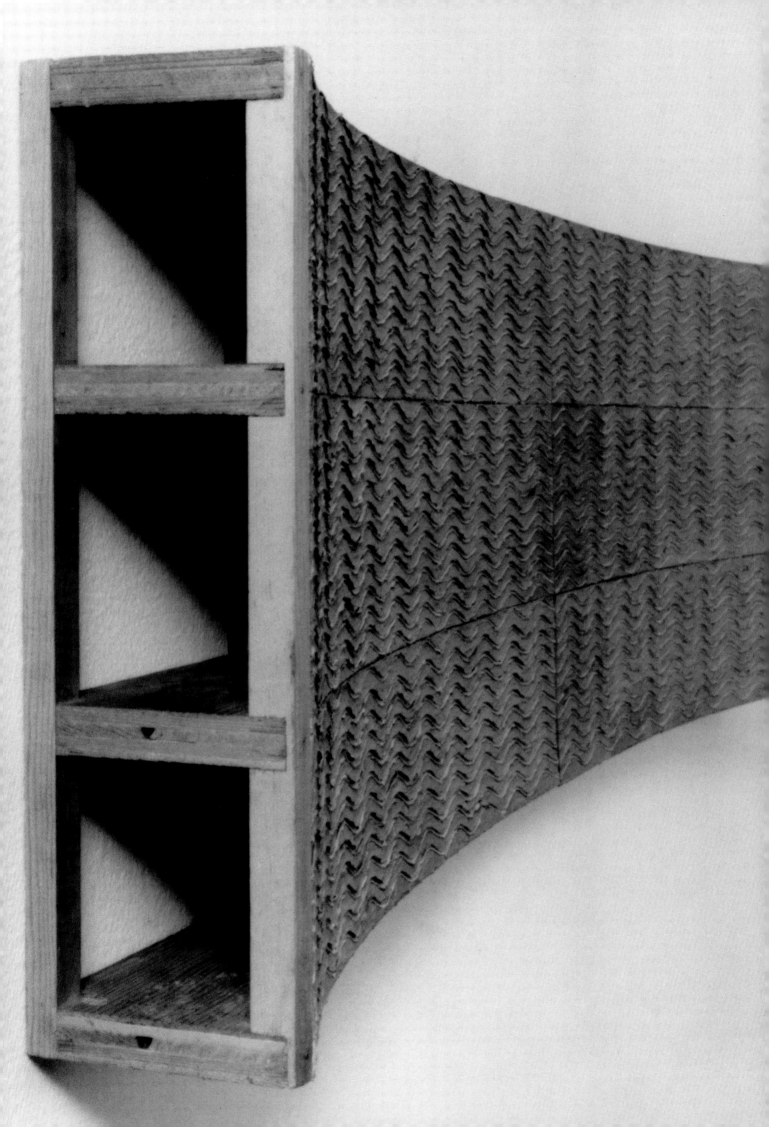

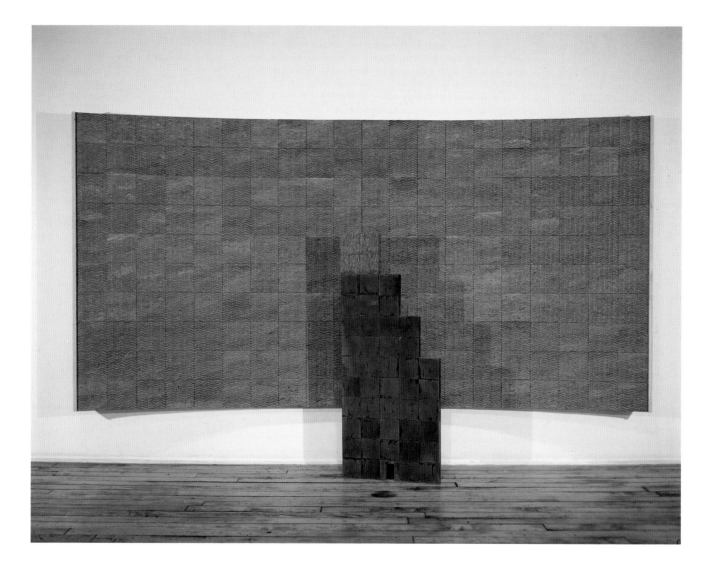

Riverview (Penthouse Fire), 1980

Acrylic and compound on board, 60 x 100 x 8 inches

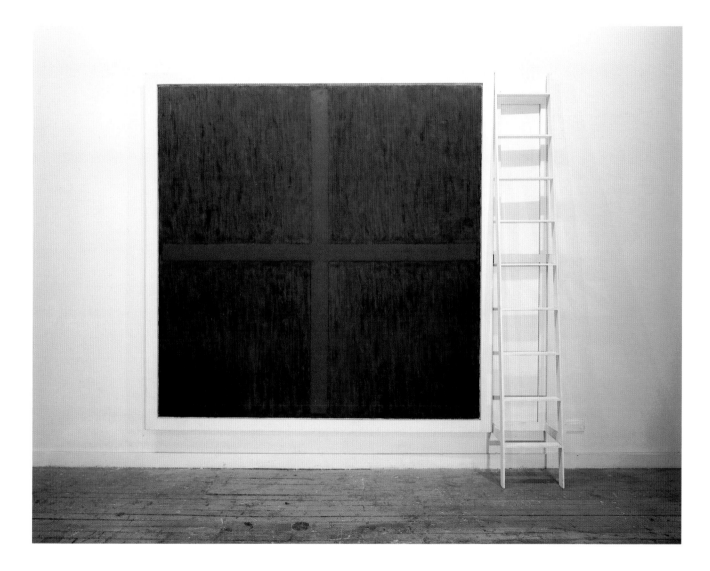

Cross with Ladder, 1984–85

Oil, wax, canvas, wood, 84 x 97 x 13 inches

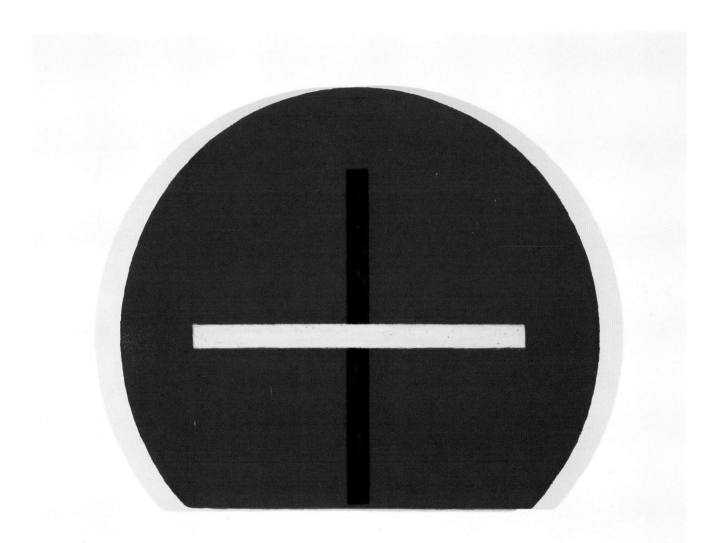

Black and White Cross Encircled by Red, 1988

Oil, wax, canvas, wood, 42 x 49 x 3½ inches

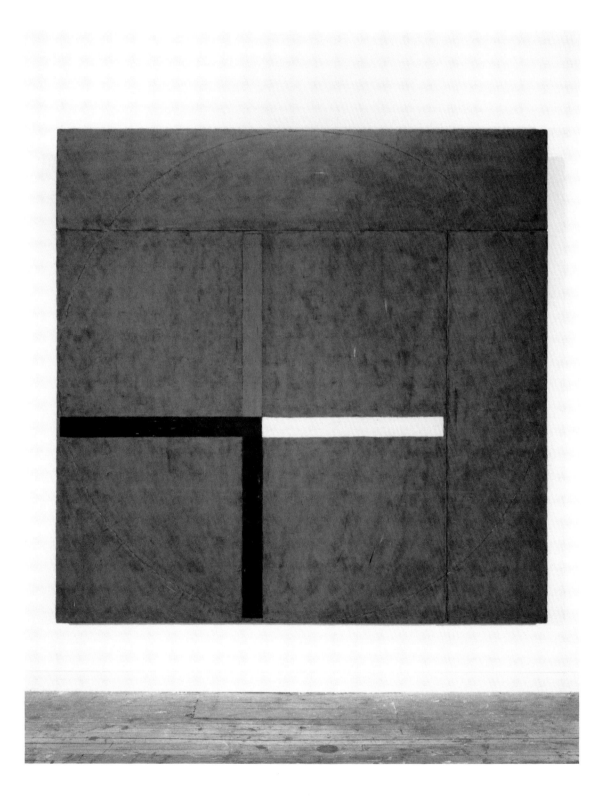

Tri-Color Cross, Encircled in 3 Gray Panels, 1988 (detail following page)

Oil, wax, canvas, wood, 88 x 88 x 4½ inches

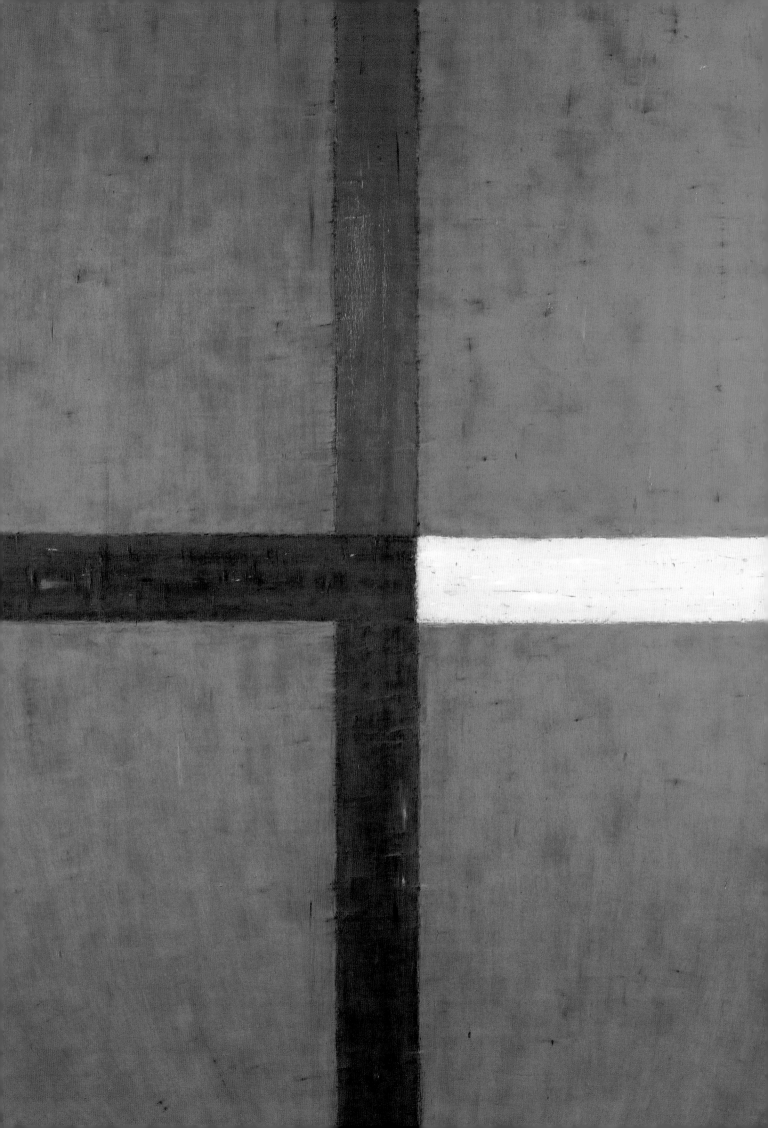

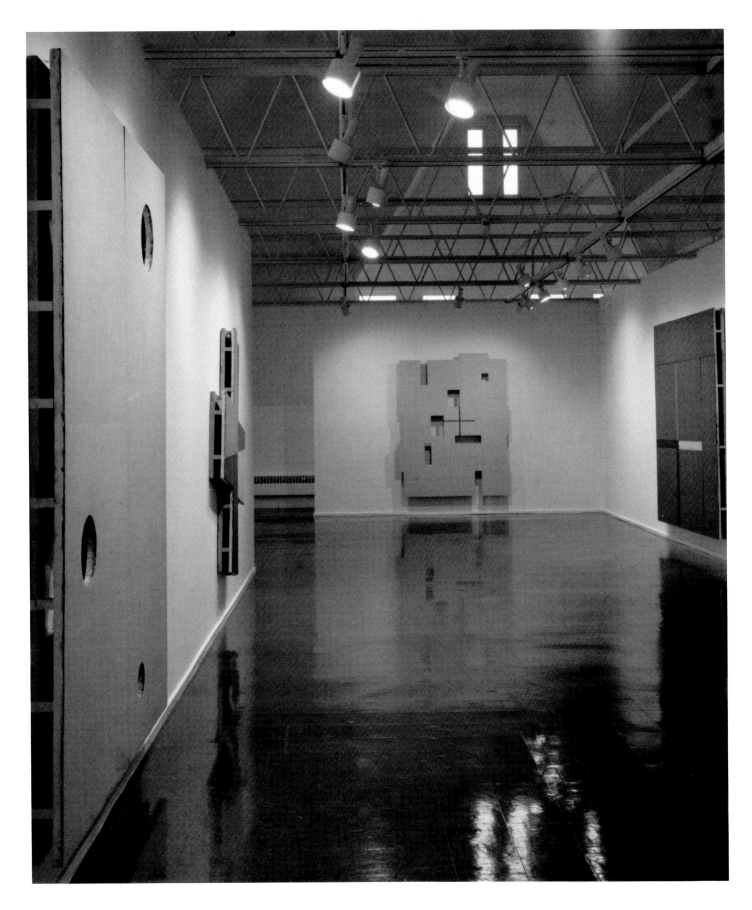

Installation view, left to right

Cross in Light Gray-Green (Split) with 3 Holes, 1991; Cross: Split, Tilted and Squared, 1989;
Irregular Stack and Cross, 1993; and Tri-Color Cross, Encircled in 3 Gray Panels, 1988

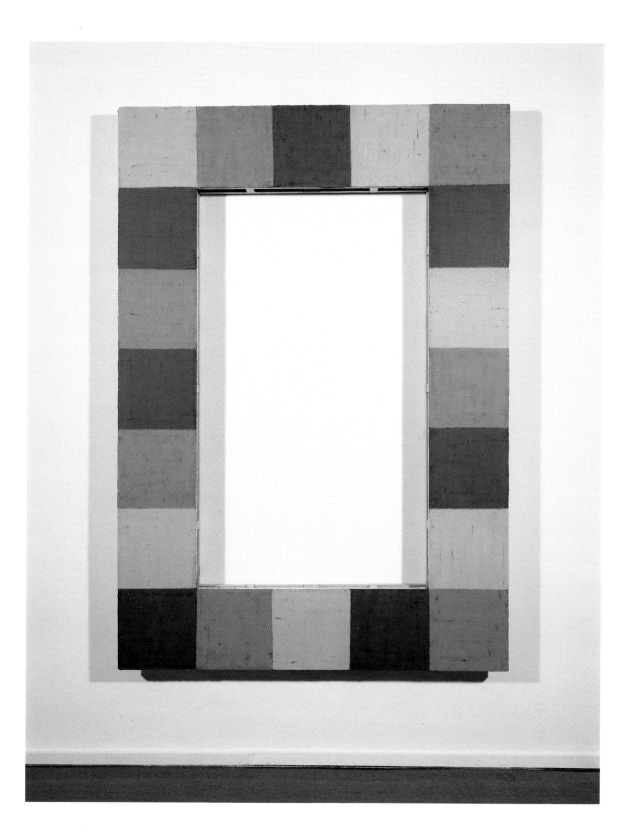

Two Grays and Orange Around an Empty Rectangle, 1988

Oil, wax, canvas, wood, 66 x 47 x 4 inches

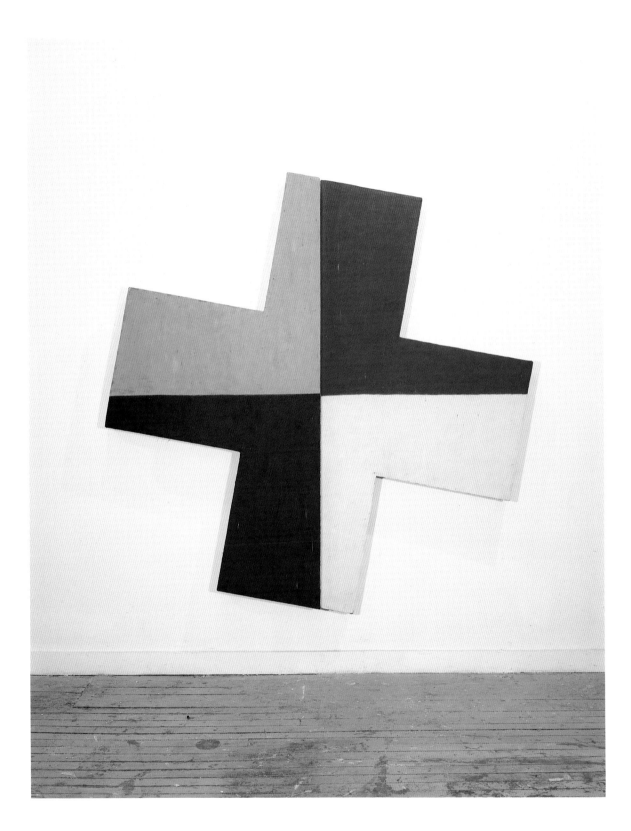

Cross: Split, Tilted and Squared, 1989

Oil, wax, canvas, wood, 68 x 68 x 4 inches

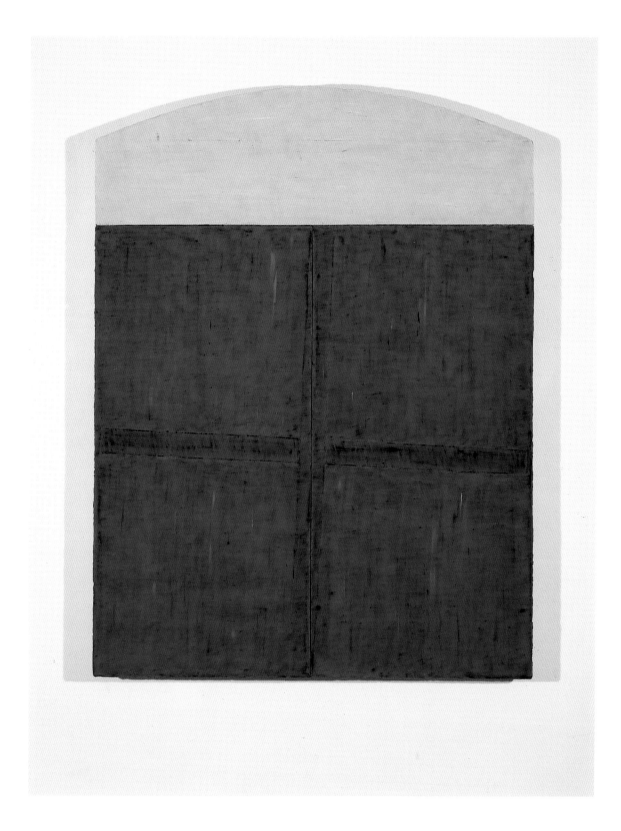

(Ghost) Split in 2 Blue Panels, 1989

Oil, wax, canvas, wood, 54 x 41 x 4 inches

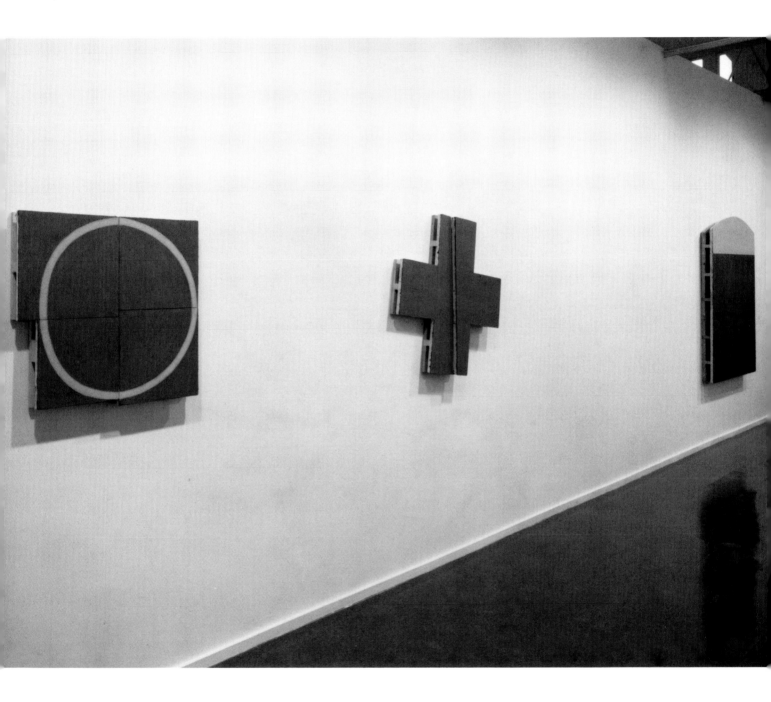

Installation view, left to right
**Circle (Distorted) in 4 Blue Squares, 1987; Red Cross: Tilted and Split, 1990;
and (Ghost) Split in 2 Blue Panels, 1989**

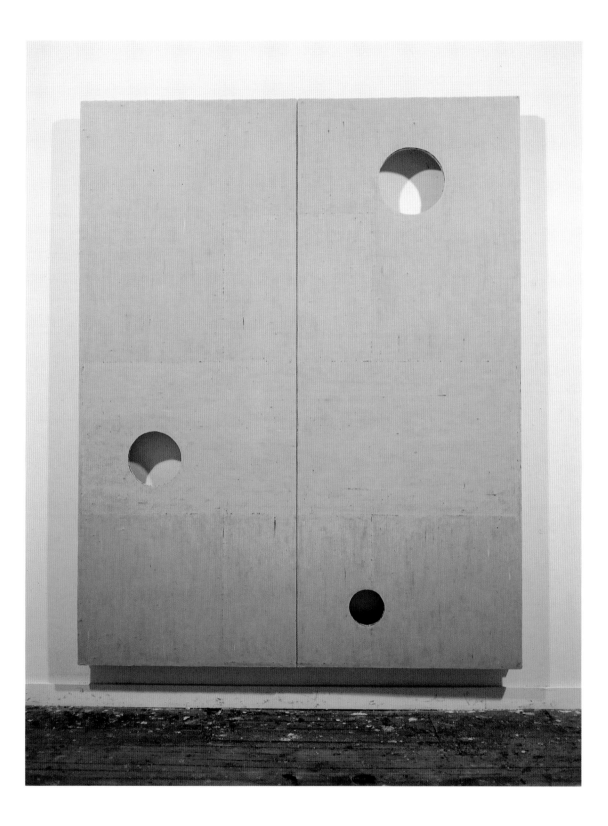

Cross in Light Gray-Green (Split) with 3 Holes, 1991

Oil, wax, canvas, wood, 90 x 72 x 4½ inches

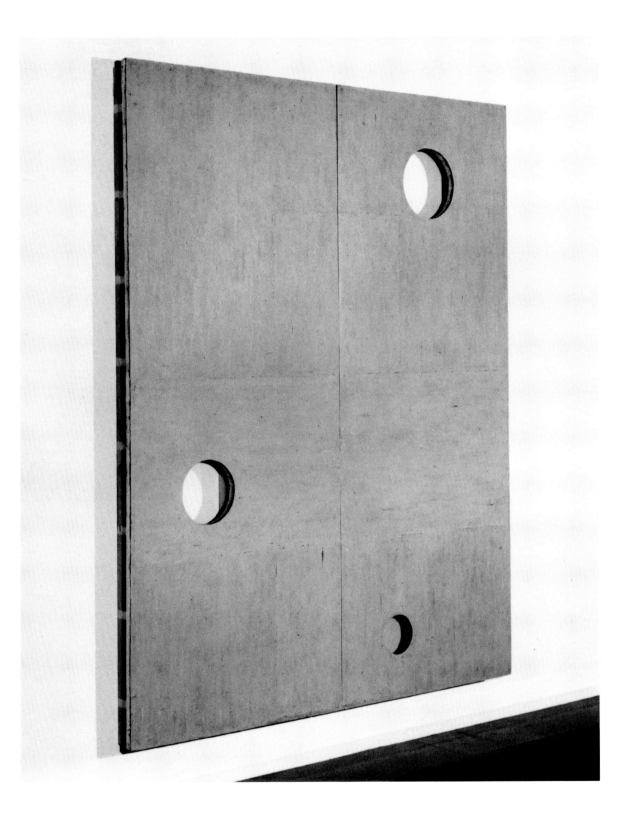

Cross in Light Gray-Green (Split) with 3 Holes, 1991

Oil, wax, canvas, wood, 90 x 72 x 4½ inches

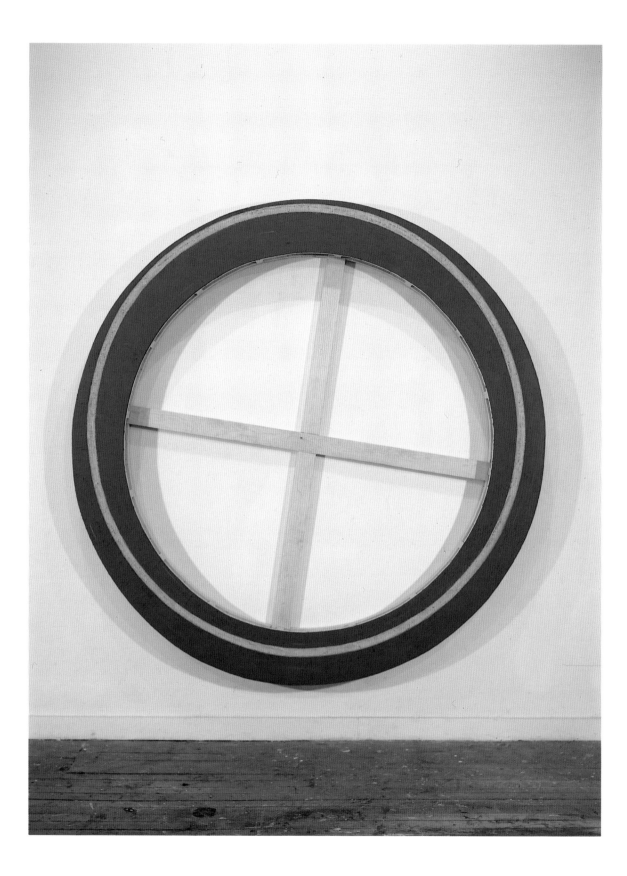

Open Circle: Encircled and Crossed, 1992

Oil, wax, canvas, wood, 76 x 76 x 4 inches

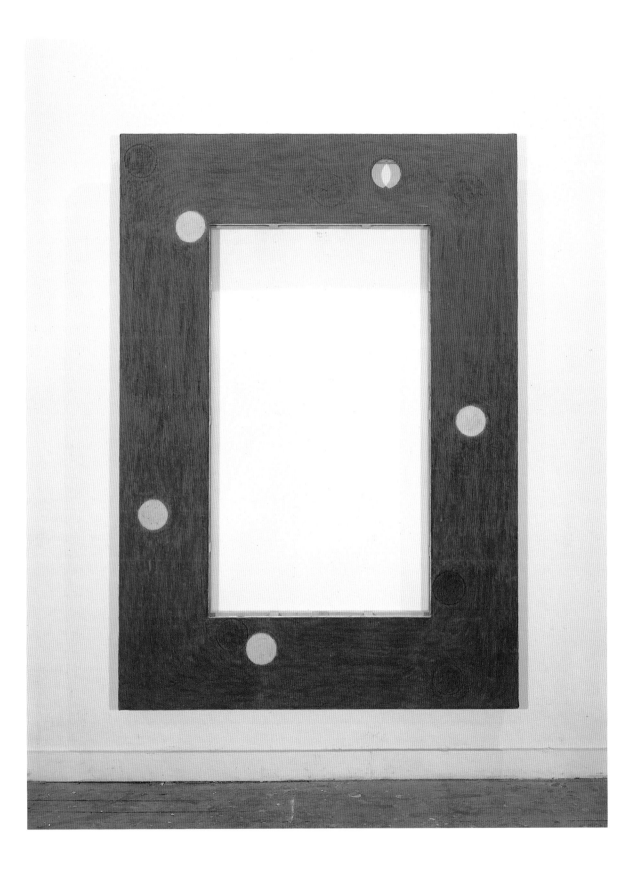

Orange Border with Spots, 1992

Oil, wax, canvas, wood, 70 x 52 x 4½ inches

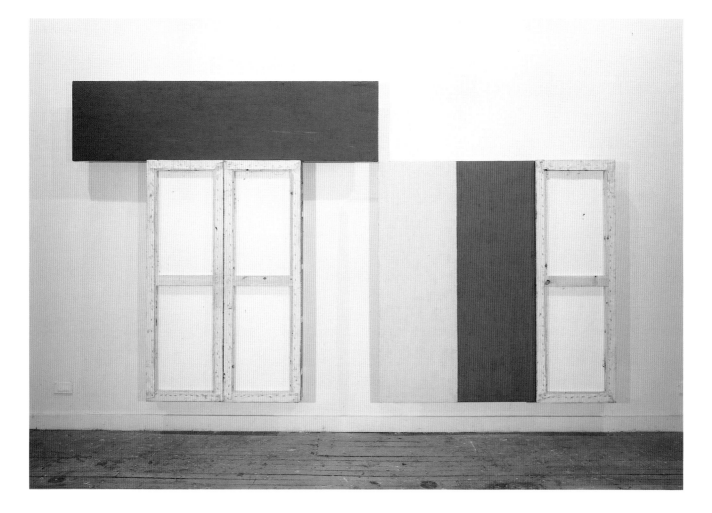

3 (5) Panels, Presented and Reversed, 1993

Oil, wax, canvas, wood, 72 x 126 x 5½ inches

3 (5) Panels, Presented and Reversed, 1993 (side view)

Oil, wax, canvas, wood, 72 x 126 x 5½ inches

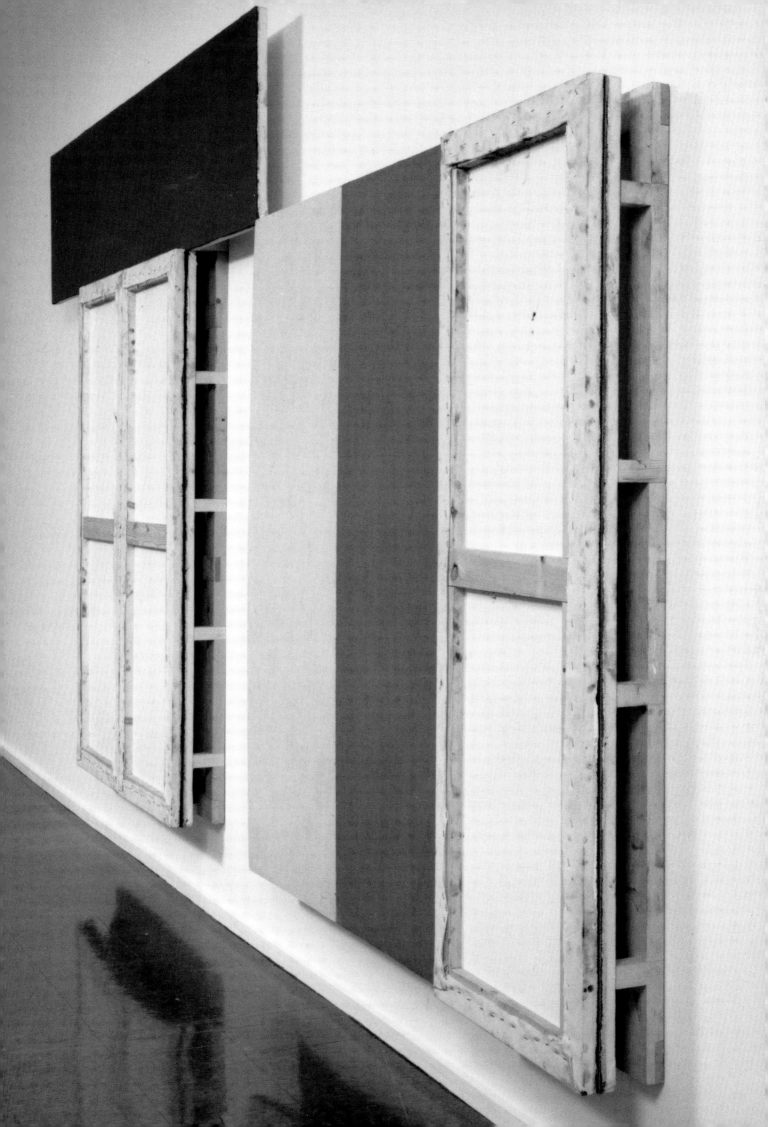

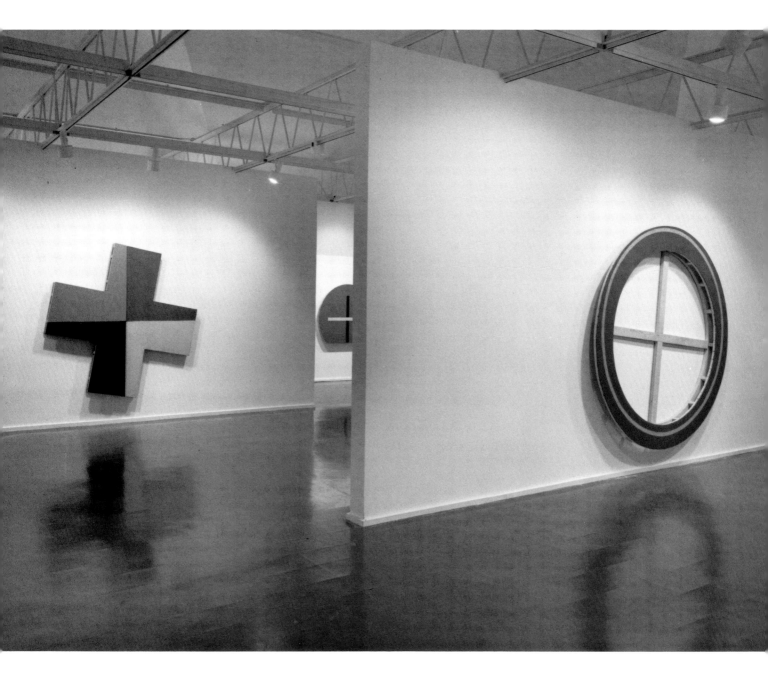

Installation view, left to right
**Cross: Split, Tilted and Squared, 1989; Black and White Cross Encircled by Red, 1988;
and Open Circle: Encircled and Crossed, 1992**

Exhibition List

1.
Newspaper Group, numbers 6, 7, 13, 17, 1975
Acrylic on newspaper, 20½ x 29½ inches
Lent by the artist

2.
Martha, 1977
Acrylic on canvas, 67 x 68 inches
Lent by the artist

3.
Newsshape, numbers 6 and 9, 1978
Acrylic and oil on newspaper, 21 x 30½ inches
Lent by the artist

4.
Twyla, 1978
Acrylic on canvas, 68 x 37½ inches
Lent by the artist

5.
St. Tropez, 1978
Acrylic on board, 15 x 50 x 3½ inches
Lent by Ken and Jan Holder, Bloomington, Illinois

6.
Cross with Ladder, 1984–85
Oil, wax, canvas, wood, 84 x 97 x 13 inches
Lent by the artist

7.
Circle (Distorted) in 4 Blue Squares, 1987
Oil, wax, canvas, wood, 24 x 25 x 3 inches
Lent by Martin Friedman, Chicago

8.
Black and White Cross Encircled by Red, 1988
Oil, wax, canvas, wood, 42 x 49 x 3½ inches
Lent by Mulvane Art Museum, Washburn University, Topeka

9.
Tri-Color Cross, Encircled in 3 Gray Panels, 1988
Oil, wax, canvas, wood, 88 x 88 x 4½ inches
Lent by the artist

10.
Two Grays and Orange Around an Empty Rectangle, 1988
Oil, wax, canvas, wood, 66 x 47 x 4 inches
Lent by Irv and Natalie Forman, Santa Fe

11.
Cross: Split, Tilted and Squared, 1989
Oil, wax, canvas, wood, 68 x 68 x 4 inches
Lent by Richland Community College, Decatur, Illinois

12.
(Ghost) Split in 2 Blue Panels, 1989
Oil, wax, canvas, wood, 54 x 41 x 4 inches
Lent by Thomas C. and Linda Heagy, Chicago

13.
Red Cross: Tilted and Split, 1990
Oil, wax, wood, 30 x 30 x 3½ inches
Lent by Jack and Sandra Guthman, Chicago

14.
Cross in Light Gray-Green (Split) with 3 Holes, 1991
Oil, wax, canvas, wood, 90 x 72 x 4½ inches
Lent by the artist courtesy of Linda Durham Gallery, Santa Fe

15.
3 Colors — 10 Sides, 1991
Acrylic on wood, 24 x 22 x 2½ inches
Lent by Mr. and Mrs. Gilbert Palay, Milwaukee

16.
Open Circle: Encircled and Crossed, 1992
Oil, wax, canvas, wood, 76 x 76 x 4 inches
Lent by the artist courtesy of Roy Boyd Gallery, Chicago

17.
Irregular Stack and Cross, 1993
Oil, wax, canvas, wood, 80½ x 66 x 6 inches
Lent by the artist courtesy of Roy Boyd Gallery, Chicago

18.
3 (5) Panels, Presented and Reversed, 1993
Oil, wax, canvas, wood, 72 x 126 x 5½ inches
Lent by the artist courtesy of Roy Boyd Gallery, Chicago

Rodney Carswell

Born

1946 Carmel, California
Lives and works in Chicago

Education

1968 BFA, University of New Mexico, Albuquerque
1972 MFA, University of Colorado, Boulder

Selected One-person Exhibitions

1992
Linda Durham Gallery, Santa Fe
Roy Boyd Gallery, Chicago
1991
Roy Boyd Gallery, Santa Monica
1989
Roy Boyd Gallery, Chicago
Miami University Museum of Art, Oxford, Ohio
Roy Boyd Gallery, Los Angeles
1988
University of Oklahoma Museum of Art, Norman
(catalogue)
Roy Boyd Gallery, Chicago
1987
Roy Boyd Gallery, Los Angeles
1986
Sangamon State University, Springfield, Illinois
1985
Roy Boyd Gallery, Chicago
1981
Roy Boyd Gallery, Chicago
1978
Roy Boyd Gallery, Chicago
1976
Not in New York Gallery, Cincinnati

Selected Group Exhibitions

1992
New Acquisitions, Illinois State Museum, Springfield
New Acquisitions, Mulvane Art Museum, Washburn
University, Topeka (catalogue)
Illinois Painters Invitational, Western Illinois University
Art Museum, McComb
Robischon Art Gallery, Denver
1991
Rodney Carswell, Susan Linnell, Otis Jones, Graham
Gallery, Albuquerque
Timothy Arp, Rodney Carswell, Constance DeJong,
Mulvane Art Museum, Washburn University, Topeka
(catalogue)
State of the Art, Biennial National Invitational
Watercolor Exhibition, Parkland College, Champaign,
Illinois

1990
Rodney Carswell, Steve Catron, Karen Yank, Linda
Durham Gallery, Santa Fe
The Chicago Show, The Chicago Cultural Center
(organized by the Museum of Contemporary Art and
The Art Institute of Chicago)
*Calder Gallery Presents: Selections from the Roy Boyd
Gallery,* Calder Fine Arts Center, Grand Valley State
University, Allendale, Michigan

1989
Material Matters, College of DuPage Arts Center
Gallery, Glen Ellyn, Illinois
Chicago, Maier Museum of Art, Randolph-Macon
Women's College, Lynchburg, Virginia

1988
Tremors, Clark Arts Center Gallery, Rockford College,
Illinois
Invitational Exhibition, Marilyn Pearl Gallery, New York
Good Painting, State of Illinois Art Gallery, Chicago

1987
Surfaces: Two Decades of Painting in Chicago, Terra
Museum of American Art, Chicago (catalogue)
Roy Boyd Gallery, Chicago
Abstract Painting, Limelight, Chicago
Works on Paper, Roy Boyd Gallery, Los Angeles
*Rodney Carswell, Renee DuBois, Barry Tinsley, Frances
Whitehead,* Illinois State University Gallery, Normal

1986
Roy Boyd Gallery, Chicago
Artists Go to Bat, Marianne Deson Gallery, Chicago
Illinois Artists Fellowship Exhibition, State of Illinois Art
Gallery, Chicago

1985
Abstract Painting in Chicago, Lakeview Center for the
Arts, Peoria; Roy Boyd Gallery, Los Angeles
Constructures: New Perimetrics in Abstract Painting,
Nohra Haime Gallery, New York (catalogue)

1984
Abstract Painting in Chicago, Roy Boyd Gallery, Chicago
Object, Image, Idea, Burpee Art Museum, Rockford,
Illinois (catalogue)
Roy Boyd Gallery, Chicago

1983
National Traveling Print Exhibition, Illinois State
University Gallery, Normal

1982
National Small Painting Exhibition, Grey Art Gallery,
New York University, New York
Recent Work, Roy Boyd Gallery, Chicago
Illinois Painters III, a traveling exhibition organized by
the Illinois Arts Council (catalogue)

1981
Rodney Carswell, Bill Drew, Josef Gallery, New York

1980
Joslyn Biennial, Joslyn Art Museum, Omaha
Midwestern Annual, Evansville Museum of Arts and
Sciences, Evansville, Indiana
Roy Boyd Gallery, Chicago

1979
Illinois Artists, Converse College, Spartansburg, South
Carolina
Rodney Carswell and Renee DuBois, Barat College, Lake
Forest, Illinois
Midwest Regional Exhibition, Quincy Arts Club, Quincy,
Illinois
Roy Boyd Gallery, Chicago

1978
Joslyn Biennial, Joslyn Art Museum, Omaha

1977
Rodney Carswell, Renee DuBois, Jeff Way, Carl Solway
Gallery, New York
The Chosen Object, Joslyn Art Museum, Omaha
(catalogue)
Painting Invitational, Ohio University, Athens

1976
Illinois Artists '76, A Bicentennial Exhibition, a traveling
exhibition organized by Illinois State University,
Normal
Normal-LAX, The Bloomington Group, California State
University, Los Angeles
New Horizons in Art, North Shore Art League, Chicago

1975
Rodney Carswell and Renee DuBois, Rockford College,
Rockford, Illinois; Albion College, Albion, Michigan;
Peoria Art Guild, Peoria
Invitational Exhibition, Beloit College, Beloit, Wisconsin

1974
Three Painters, Not In New York Gallery, Cincinnati
The Ponderosa Collection, Contemporary Art Center,
Cincinnati
Illinois Invitational, Illinois State Museum, Springfield
Critics' Choice, Lakeview Center for the Arts, Peoria
Illinois Artists '74, Center for the Visual Arts Gallery,
Illinois State University, Normal
Four Painters, 118, An Art Gallery, Minneapolis

1973
*The Seventy-fourth Exhibition of Artists of Chicago and
Vicinity,* The Art Institute of Chicago
Illinois Invitational, Illinois State Museum, Springfield

Bibliography

Catalogues

Donato, Debra. *Good Painting: Contemporary Chicago
Painters.* State of Illinois Art Gallery, Chicago: 1988.
Illinois Arts Council. *Illinois Painters III.* Illinois Arts
Council, Springfield: 1982.
Joslyn Art Museum. *The Chosen Object.* Joslyn Art
Museum, Omaha: 1977.

Kirshner, Judith. *Surfaces: Two Decades of Painting in Chicago.* Terra Museum of American Art, Chicago: 1987.

Mulvane Art Museum. *Timothy Arp, Rodney Carswell, Constance DeJong.* Washburn University, Topeka: 1991.

_____. *New Acquisitions.* Washburn University, Topeka: 1992.

Rockford Art Association at Burpee Museum. *Object, Image, Idea: Vision in the Eighties.* Rockford Art Association, Rockford, Illinois: 1984.

University of Oklahoma Museum of Art. *Rodney Carswell.* University of Oklahoma, Norman: 1988.

Articles

Adrian, Dennis. "Two Decades of Painting in Chicago, Beneath the Surfaces," *New Art Examiner* (Dec., 1987), pp. 26–9.

Artner, Alan. "Terra Incognita," *Chicago Tribune* (Sept. 13, 1987), Arts Section, pp. 10–11.

_____. "A man who is able to convince in a number of formats," *Chicago Tribune* (June 3, 1988), sec. 7, p. 36.

_____. "Rodney Carswell," *Chicago Tribune* (Fri., Feb. 14, 1992), sec. 7, p. 44.

Bonesteel, Michael. "Skimming the Surfaces at the Terra Museum," Pioneer Press community newspapers (Oct., 1987).

Curtis, Cathy. "Review," *Los Angeles Times* (Feb., 1989), p. 12.

Fernandes, Joyce. "Good Painting: Contemporary Chicago Painters," *New Art Examiner* (June, 1988), pp. 42–3.

Frank, Peter. "Reconstructivist Painting: Neo-Modern Painting in the United States," *Art Space* (Mar.–Apr., 1990), pp. 44–50.

Holg, Garrett. "Hometown Chicago," *The News Sun* (Oct. 29, 1987), p. 9K.

Lubell, Ellen. "Three Artists," *Arts Magazine* (Sept., 1977), pp. 37–8.

McCracken, David. "It's hard to classify 'Good Painting' works," *Chicago Tribune* (Apr. 1, 1988), sec. 7, p. 52.

_____. "Rodney Carswell on painters and painting," *Chicago Tribune* (June 10, 1988), sec. 7, p. 54.

Miotke, Anne E. "Stretched Canvases, Free of the Stretcher," *Midwest Art* (Mar., 1976), pp. 16–17.

Pieszak, Devonna. "Rodney Carswell," *New Art Examiner* (Apr., 1978), p. 16.

Porges, Timothy. "Chicago," *Contemporanea* (July/Aug., 1988), pp. 32–3.

Schulze, Franz. "The Chicago and Vicinity Show," *Chicago Daily News* (Mar. 24, 1973), Panorama Section, pp. 1–3.

Wilson, William. "Rodney Carswell at Roy Boyd," *Los Angeles Times* (Mar. 13, 1987), sec. 4, p. 12.

_____. "The Windy City Polishes Its Art Scene," *Los Angeles Times* (Oct. 18, 1987), Calendar Section, pp. 99–101.

Yood, James. "Rodney Carswell," *New Art Examiner* (Sept., 1988), p. 46.

_____. "Rodney Carswell," *Artforum* (Apr., 1992), p. 102.

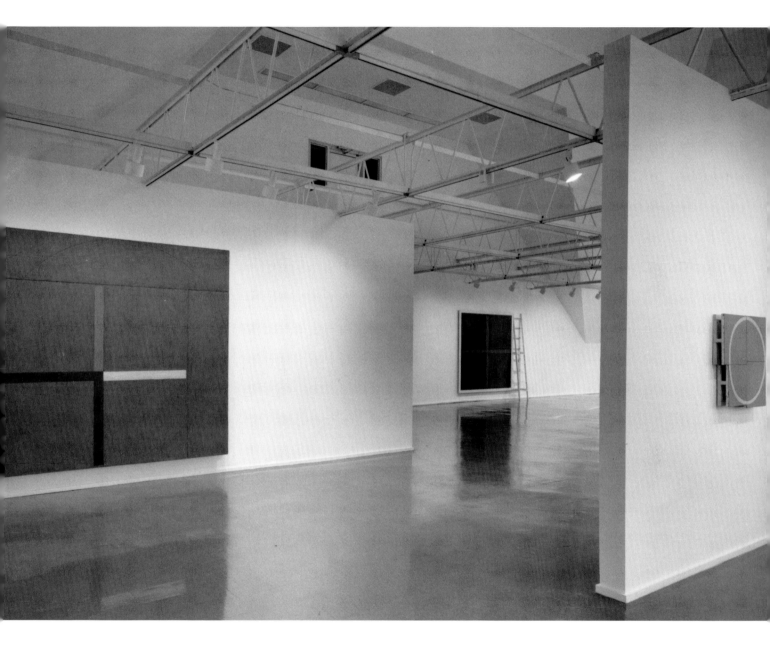

Installation view, left to right
**Tri-Color Cross, Encircled in 3 Gray Panels, 1988; Cross with Ladder, 1984–85;
and Circle (Distorted) in 4 Blue Squares, 1987**

This catalogue has been made possible with the generous support of Sahara Coal Company, Inc., LaSalle National Bank, Chicago, and the Elizabeth Firestone Graham Foundation.

The exhibition is sponsored in part by the Illinois Arts Council, a state agency; by the CityArts Program of the Chicago Department of Cultural Affairs, a municipal agency; and by our membership. Indirect support has been received from the Institute of Museum Services, a federal agency offering general operating support to the nation's museums.

Generous support has been received from The School of Art and Design and The College of Architecture, Art, and Urban Planning at The University of Illinois at Chicago, and from Linda Durham, Timothy and Suzette Flood, Martin Friedman, Daryl E. Gerber, Michael Glass and Michael Glass Design, Jack and Sandra Guthman, Thomas C. and Linda Heagy, Jessica D. Holt, and Claire F. and Gordon Prussian.

ISBN 0-941548-26-0
The Renaissance Society at The University of Chicago

© 1993 The Renaissance Society at The University of Chicago

Designed by Michael Glass Design, Chicago
Edited by Joseph Scanlan
Photographs by Tom van Eynde, Forest Park, Illinois, and
Michael Tropea, Highland Park, Illinois
Typesetting by Paul Baker Typography, Inc., Evanston, Illinois
Printed by Meridian, East Greenwich, Rhode Island

Inside front and back cover
Untitled, 1984, Oil and wax on board (destroyed)

Cover
Cross in Light Gray-Green (Split) with 3 Holes, 1991 (detail), oil, wax, canvas, wood, 90 x 72 x 4½ inches